THOUGHT PROVOKING THOUGHTS

A perspective to think life!

VINITA KOTHARI

Thought Provoking Thoughts: A perspective to think life!
by Vinita Kothari

ISBN 978-1-952027-86-4 (Paperback)
ISBN 978-1-952027-87-1 (Hardback)

This book is written to provide information and motivation to readers. Its purpose is not to render any type of psychological, legal, or professional advice of any kind. The content is the sole opinion and expression of the author, and not necessarily that of the publisher.

Copyright © 2020 by Vinita Kothari

All rights reserved. No part of this book may be reproduced, transmitted, or distributed in any form by any means, including, but not limited to, recording, photocopying, or taking screenshots of parts of the book, without prior written permission from the author or the publisher. Brief quotations for noncommercial purposes, such as book reviews, permitted by Fair Use of the U.S. Copyright Law, are allowed without written permissions, as long as such quotations do not cause damage to the book's commercial value. For permissions, write to the publisher, whose address is stated below.

Printed in the United States of America.

New Leaf Media, LLC
175 S. 3rd Street, Suite 200
Columbus, OH 43215
www.thenewleafmedia.com

Contents

#	Themes	Page no.
1	Life & Death	1
2	Relationship	3
3	Marriage & Side Effects	5
4	Patience	7
5	Smile	9
6	Hilarious	11
7	Karmas	13
8	Life's temporary	15
9	Diplomacy at its best	17
10	Criticism	19
11	Self Obsession	21
12	Food for Thought	23
13	True test of love	25
14	Being Happy	27
15	Success and Hard work	29
16	Friendship	31
17	Expectation	33
18	Stress/ Tension	35
19	Independence	37

Life & Death

1) Life is like a marathon
 There is risk of losing
 If you walk slow;
 But that doesn't mean that
 Everyone who walks fast wins

2) Life is so vexing
 For some routine life is maddening;
 And for others
 Life full of challenges is exasperating

3) Life is never satisfying
 This is either because
 We expect a lot;
 Or because we always
 Dream about a bright future

4) Living in the present
 Is equally important
 As always thinking
 About a bright future
 And, for a bright tomorrow
 Past needs to be chucked

5) "Khaali haath aaye hain hum (we have come empty handed)
Khaali haath jayenge (We shall go empty handed)"
Is a phrase aptly said
But hardly understood in practical life

6) We jostle in life for peace
We jostle in life for happiness
We jostle in life for future
Sometimes I really wonder
Is life really meant to jostle for materialistic things?

7) Life comes in phases
Infant, Childhood, Youth, Middle age, Old Age
Each phase has its own charisma, experiences and challenges
No phase of life can be lived in a pre-defined manner
And each phase needs to be encountered on own.

Relationship

8) I wonder why God created these 'relationships'
 Those which we want, never lasts long
 The ones which we never want, lasts forever

9) Dependency is worst
 Relationship makes you dependent

10) Ship of relations
 Easy to build
 But difficult to sail through
 Relationships like Ships
 Sail through a rough and course patch

11) Alas I sometimes feel lost
 In this vast ocean of relationships
 I feel lonely even when surrounded
 By my near and dear ones

12) There is a constant challenge to build
 And sustain relationships
 For it is in our hands
 Whether, to complicate relationships
 Or take it EASY

Marriage and side effects

13) High profile weddings
 Is just waste of hard earned money
 Which hardly lasts long in true sense today
 High time to overhaul the entire idea of weddings

14) This is with due courtesy to married folks
 Marriage is a big hurdle in fulfilment of life's fondest wishes
 It eats most of your precious time and cuts down the wish list
 Which otherwise could have been spent on much fruitful endeavours

15) As it is said "Men will remain MEN"
 They can never understand a "WOMEN"
 Expecting men to understand women's life, aspirations, and sacrifices
 Can only be said to be 'foolish'.

Patience

16) Frustration can subside
 Only with patience
 Else it can only mess up
 Already messed up life

17) Hard work, sincerity and dedication
 All lead to the path to success
 But,
 The mother of success
 Indeed is Patience

18) I am patient
 But that does not mean that 'I am dumb'
 It only means that "I am listening'

19) Patience is a virtue
 Gained with age
 One who gains it before ageing
 Indeed is a captor

20) Stay calm inside
Whatever be the turbulence outside

21) Life has its own Highs and Lows
Real winner is one who
Stays calm in 'High'
And
Retains 'patience' when low

Smile

22) Two places where smile works best
 To avoid unnecessary arguments
 And
 To avoid unwanted people

23) Keep Smiling
 It's a synonym of "intelligence"

24) Best approach to pacify your enemy
 Is to smile on his face
 This can prove to be the biggest revenge

25) A smile can be contagious
 And dissolve all ill feelings

26) Keep Smiling as it costs nothing
 Save the tears as they are precious

Hilarious

27) It rightly said that
Grandparents and grandchildren
Share a common enemy in between

28) Being with a child
I feel is the true
Test of patience

29) Best synonym of enemies
Husband and wife

30) No couple in world is happy after marriage
This indeed is a global phenomenon!

31) Empty handed u enter life
Empty handed u exit life
In between all you do is
Just a time pass!!

Karmas

32) Fed up with this tussle called 'life'
 But,
 You can only blame 'your' karmas for that

33) Seeds you sow are bound to reap
 Karmas you indulge
 Are bound to bounce

34) Do good to others
 Think good about others
 No matter what others
 Do or think about you

35) I only vow for goods karmas
 Sadly,
 I hardly engage in goods karmas

36) One has to pay off his karma (deeds) himself
 For no one can set off other's karmas with his

Life's 'Temporary'

37) Its aptly said that nothing is constant
Except 'constant change'
As when I look back in life
I feel I have lost everything
And
What I still have with me is 'constant change'

38) Life is under a constant treat
And that threat is "Death"
Let me tell you the truth
There is no such thing called 'death'
It is only our body which dies
But our soul never dies

39) Nobody can solve my worries
But only "me"
Nobody can ease my tension
But "me"
No point shrugging worries n tension on others
It will only enhance and not alleviate it

40) I feel lonely
 I feel alone
 But off late I realised that
 Life is all about being 'lonely' and 'alone'

41) I struggled all my life for peace
 Which I still haven't attained
 I cried hard all my life for tranquilty
 Which seems far stretched a dream now
 But the hard truth is that
 I am born to die
 Then why should I cry

Diplomacy at its best

42) Diplomacy is when People
 Talk different on face and
 Act different at back
 Ah sad part is that
 Diplomacy prevails over honesty!

43) Just because I talk to you
 Does not mean
 'I Like u'
 It means I am only being
 'Diplomatic'

44) I am being Diplomatic
 When 'I am'
 What 'I am not'

45) Hundreds of people
 Gives me 'thousands' of unwanted advice
 Don't know why giving advice is 'FREE'
 I just behave diplomatic
 By hearing it from one ear and
 Throwing it out of the 'other'

46) A diplomatic person
 Is one who

May not like to 'speak truth' as much as
He would like to speak what 'pleases others to hear'

47) There is some trick to handling diplomatic persons
Smile when they say
Avoid when they bang
Be silent when they speak
Diplomacy at its best!

Criticism / Jealousy

48) Never speak up in front of critics
 Let your triumph speak
 Your success will speak for your unspoken words

49) Jealousy yields no results and
 Is only detrimental to your mental and physical health
 A jealous person can only 'injure' himself
 But his jealousy cannot 'injure' others

50) Men will always be men
 Criticism from them
 Should be thrown in gutter

51) There is no force in what men say
 To a women when in 'anger'

Self Obsession

52) Dump your 'self obsession'
While speaking to self obsessed people
As conversation between 2 self obsessed persons
Can only lead to 'nowhere'

53) Mirror image is the true test
For self obsessed persons

54) Speak less,
And
Let your actions speak more

55) I am simple, I speak less
Does not mean that "I don't have a "brain"
The truth in fact is that
Complicated people use less "brain"

56) The most misconceived person
Is one who believe
"I am the best"

Food for thought

57) Food ought to taken as a medicine
 Else it will lead you towards medicine!

58) To make others understand is still easy
 However to make understand oneself
 Is challenging

59) Two 'T's which have
 Messed up
 Life today is
 Television and **T**witter

60) Two most prized possessions of life
 Are tears and values
 Can't waste them for fools
 But alas
 Contrary is real story

61) Bedroom and Boardroom's secret
Should never be leaked
It can prove dangerous

62) Technology is good
If used judiciously
Else, it can prove detrimental

63) Child upbringing is more about
inculcating right set of value system
rather than just ranking up the child
in the rhetoric education system

True test of 'Love'

64) Love is not when I express it
Love is when the other person can feel it
This is true test of love!

65) It hurts you when
Your loved one is in pain
This is true test of love!

66) True love is when one can
Let go of your fault but
Cannot let you go
This is true test of love!

67) If one cannot let go of others fault
Without making a hullabaloo
Love is just superficial
On the face of it.

Being Happy

68) Happiness is just a state of mind
Which can only be attained
If one can let go of external disorder

69) Your are happy
So far as you are single!

70) My face glows when I am happy
So If I am not happy, don't ask about it
As my face will say it all

71) Democratically speaking,
Happiness is not about money,
cars, jewellery and other riches
It is all about independence and sovereignty

Success and Hard work

72) Always remember
 While enjoying the fruit of success
 Never forget the path that lead to success
 And More Importantly
 Never forget ones who contributed to success

73) The word 'impossible' is just an excuse
 As with hard work, dedication and sincerity
 Even impossible is achievable

74) Strength cannot be built overnight
 It takes years to make an 'impact'

75) Behind every strong man
 There is tough grind and a lot of hidden sweat
 Just as
 Behind every strong wall
 There is a lot of toil and hidden labour

76) Hard work drives 'success'
 However, with 'positive energy', 'focus' and 'determination'
 Such success can lead to 'Miracle(s)'

Friendship

77) Friend is the only person
Who truly understands your silence

78) The difference between a friend and acquaintance is
That acquaintance remains will u long still knows u less
However, a friend knows u all even though hardly stays with you

79) Friendship is the only relation
Which truly bonds with age

80) Best friend is one
With whom I can even share
My wildest dreams

81) Best friend is one who makes
You feel most comfortable
In those uncomfortable moments

82) The importance of 'friend' is realized
 Not when he is there with us
 But when he is away

83) A friend is one
 Mere thought of whom
 makes u beam

Expectation

84) Expectation is the mother of all tensions
 And
 Expectation gap is the father of all tussles

85) "Don't focus on results
 Believe in actions
 Leave rest on Almighty"

86) Too much expectation from life & wife
 Leads to highly undesirable results

87) Not everyone can be a 'Perfectionist'
 Perfectionist is just an academic word
 For being 'perfect' is more difficult
 And
 Expecting 'perfection' at times unjustified

Stress / Tension

88) I pity those who don't have daughters
 As
 They are a step closer to all tensions and stress

89) I am surrounded with a million people
 Hard to find a single face
 Not saddled with 'STRESS / TENSION'

90) Somehow 'STRESS' has become
 Part of my life
 And Somehow I have learnt to
 Live with 'STRESS'

91) Nobody came to me
 In my stress
 I was left at my own mercy
 I realised hard unsaid fact
 That people come to you only in 'merry'

92) Tension can eat your
 'Body, soul and life'
 Without offering any solution
 It is best to 'chide' it away

Independence

93) Independence is my birth right
 And I cannot afford to loose it

94) Freedom to speech, freedom to thoughts
 Freedom to act and freedom to execute
 Is what all I mean by "independence"

95) Mind cannot think unless left free
 And at no cost should it be made to
 To think as per discretion of others

96) I love my Independence
 And all the more I have started loving it since the moment
 I lost it
 I never realised its importance
 When I had it

97) A liberated mind
 Has so many avenues to think
 His world is large
 His space is huge
 But Alas
 My mind never gets liberated

98) In a relationship
 Freedom of speech & expression
 Freedom of thoughts & actions
 All go in vain

99) Independence at the
 Cost of disrespecting others
 Is not a good idea

100) Independence is key to success
 As much as is 'hard work'

www.ingramcontent.com/pod-product-compliance
Lightning Source LLC
Chambersburg PA
CBHW060147230426
43661CB00003B/606